Bygone STRATHAVEN

by

Richard Stenlake

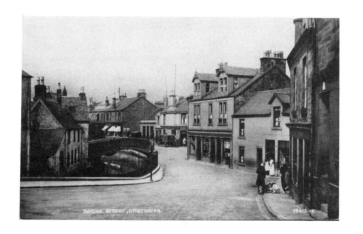

GW00468389

© Richard Stenlake1993
First Published in the United Kingdom, 1993
By Richard Stenlake, Ochiltree Sawmill, The Lade, Ochiltree, Ayrshire KA18 2NX
Telephone: 02907 266

ISBN 1-872074-27-8

LANARKSHIRE HERITAGE SERIES

FOREWORD

This little book is not a history of Strathaven. That task has been tackled several times before by various authors. These are detailed on pages 7, 8 and 9 where you will find a comprehensive bibliography. It lists the main sources for launching into further and deeper or more specific reading and research. This book is a record of a different kind, of pictures of a bygone Strathaven within or just slipping beyond living memory. The photos have been chosen to show views or aspects of town life that have changed. Yet just when I had rearranged them for the umpteenth time and made my final picture choice it struck me that someone leafing through my album in 10 or 20 or 100 years time might make a totally different selection. What looks the same today as it did 85 years ago and is hence perhaps to us "boring" may well disappear altogether anytime! If there is a moral from this, it must be a plea not to throw away any photos you may have (of anywhere) from the 1940s, 50s, 60s, 70s or even 80s just because at the moment they're of no interest to you. Better tomorrow's heritage than today's landfill!

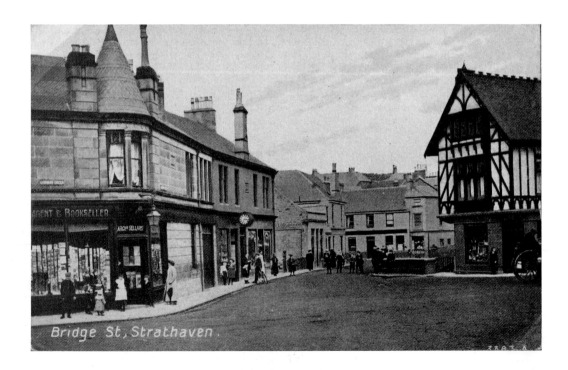

Bridge St, Strathaven.

STRATHAVEN – A Brief Potted History.

It is thought that there was a chapel at Strathaven from about the 10th or 11th century and that there was a tower-house from around the early 12th century. This was built by the Fleming or Bards (maybe Bairds) family of Biggar who were the ruling force in the area at the time. Later it belonged to the Douglas family and, in return for services rendered, in 1450 James II rewarded William, Earl of Douglas by granting him a charter raising the village to a burgh of barony. This was more than mere honour – it meant more money for William also. But the threat was always there that it could all be taken away again if there were any signs of disloyalty. Five years later that is what happened. William was killed by the king and ownership of the barony consequently reverted to the Crown.

James III subsequently granted the barony to Andrew Stewart, Lord Chancellor of Scotland, who was created the first Lord Avondale in 1457. His was a successful career – he appears to have negotiated not only the hand of the King of Denmark's daughter for James III, but also a dowry which has proved useful to this country in recent years – the Orkney and Shetland Islands. He also rebuilt and occasionally stayed at Strathaven castle, which had been burnt down during the dispute between James II and the Douglas family.

Less notable was his descendant, the third Lord Avondale, whose talents for diplomacy were limited. After a long-running dispute with neighbouring land-owners, he exchanged his castle and barony for those of Ochiltree, Ayrshire which belonged to Sir James Hamilton of Fynnart. Despite being an architect of some note (he was responsible for Craignethan Castle and possibly Garrion Tower also), in 1540 Sir James was found guilty of treason, beheaded and quartered. His estates naturally reverted to the Crown for a while, but three years later were restored to his son, also James. In 1565 the title of lordship of Avondale returned to the area when it was conferred on Sir James and the lands of Avondale have stayed with the Hamilton family as superiors to the present day.

As a burgh of barony, buying and selling was permitted within the burgh-bounds and the inhabitants were also allowed to hold a weekly Sunday market and an annual fair. However, the 'town' consisted of little more than a cluster of dwellings (a 1637 rental details about 48 houses) in the vicinity of what was then a much larger castle. It remained like this throughout the 16th and 17th centuries, presumably not helped by the entanglement of the Hamiltons in the national issues of the time – as supporters of Mary, Queen of Scots (she is said to have galloped through Corney's Close in flight after her forces' defeat at the Battle of Langside) and during Covenanting times when the people were oppressed by each side in turn. Even after peace had broken out, in the early 18th century, the place was tiny. As William Mack, in his 1811 'History of Strathaven', recounts: "During the summer of 1810, an old native of the place, William Ruthven, who is now nearly a hundred and eleven years of age, paid a visit to the town, and drew the attention of the inhabitants astonished at his great age, and at his curious anecdotes of the town in his young years; he stated that between ninety and a hundred years ago, there were but a few houses south of the old bridge … The inhabitants consisted mostly of persons who had retired from rural business, and had chosen the town for the convenience of being near the place of worship, and a few labourers and mechanics to answer the demands of the surrounding county. Such was the state of the town in 1725."

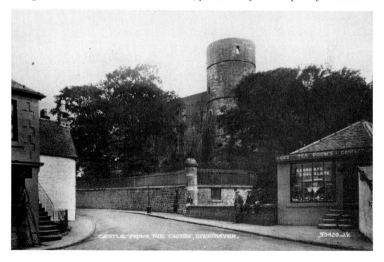

CASTLE FROM THE CROSS, STRATHAVEN.

The Duchess Hamilton, the last resident, died in 1716 and the castle was abandoned in 1725. It was then put to wide community use, especially during inclement weather. Sometimes it was used as a market-place and one of the rooms got a new lease of life as a court hall. On occasion it even served as a jail … "About this period part of the country was infested by gangs of banditti, called Annandale thieves; a number of these were apprehended, and lay bound in stocks in one of the strong rooms in 1730". Neglect and storms subsequently took their toll and it is widely stated that much of the stone from the castle was 'recycled' by the locals, though this is disputed. Certainly as the castle went to rack and ruin, literally, the town was at last making progress. The pace of economic change speeded up throughout the remainder of the eighteenth century. In 1730, the stonemasons obtained a charter from the Mother Lodge of Kilwinning and incorporated themselves as did the town's weavers and tailors (1736 both) and the shoemakers (1764). In 1744 outside enterprise arrived – a baker from Glasgow set up to make gingerbread in Strathaven. In 1745 national events again caused local upset as the Jacobite rebels passed through the town, although it was business as usual by the next year as "arts and manufactures began to acquire new vigour". Shoes were being "exported" to other parishes and in 1770 "checks and other stout fabrics of cloth" were being manufactured to feed the growing trade with "the American Colonies".

Disaster almost struck in 1782 when the crops failed, but the masons and the other three incorporated societies came to the rescue and bought white pease which they ground into meal for their families and their fellow citizens.

Silk weaving was introduced in 1788 and although the linen trade later declined it was supplanted by a trade in muslin. Around this time, the town's development was further helped by an accident of geography. A turnpike road was constructed during 1789-90 for the purpose of transporting pig iron from Muirkirk and Strathaven was on the route. Townhead, Green Street, Ball Green and Back Road were all formed at this time as a consequence. The next year a cotton mill employing 100 people was set up (it stood just above Walker's Bridge) and by 1791 there were 1610 people in the town. In 1793 there was another temporary blip in the town's fortunes when the French war broke out. The only decent business being done (at £30 a time!) was by the society formed to 'buy' substitutes to serve in the militia. A further crop failure in 1799 again resulted in the intervention of the four trade societies. Despite these and other setbacks, the population continued to swell. By 1831 it had reached 3,000 and by 1835 4,000.

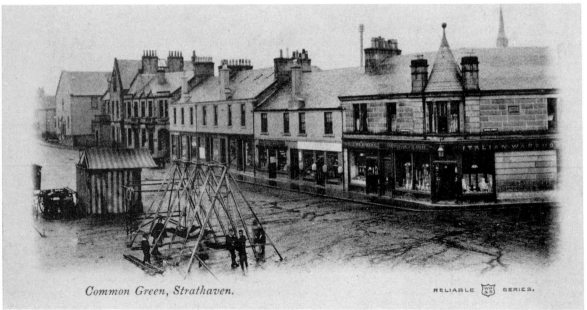

Common Green, Strathaven.

RELIABLE WR&S SERIES.

By 1810 there were 400 handloom weavers in the town. The other principal trades were shoemakers (50), stone masons (40), mill and wheel wrights (30), and tailors (20). The twenty public houses no doubt encouraged the local bent for lyrical poetry. In the autumn of 1810, a modern phenomenon, unemployment, manifested dramatically. "A general dullness of trade began to be felt, which fell particularly on the weaving branch, so that in the beginning of 1811, out of 400 weavers, formerly well employed, there were 100 thrown idle". The crisis was resolved, after a fashion, when on the morning of Sunday 11th November 1811 (11.11.11 !) the cotton mill at Walker's Bridge went on fire. It was probably arson, there having been two previous attempts to set it ablaze. This time though it burned to the ground in a short space of time and it was effectively put out of business. Following this incident, hand-loom weaving "became again the staple trade of the town" and later reached a peak of 900 thus employed.

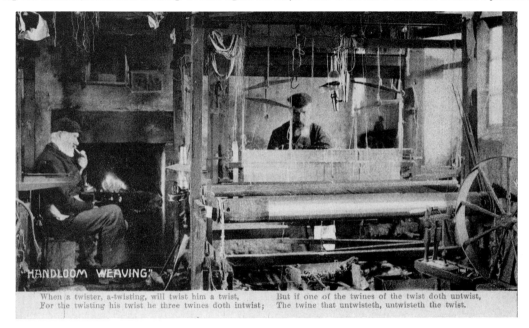

"HANDLOOM WEAVING."

When a twister, a-twisting, will twist him a twist, But if one of the twines of the twist doth untwist,
For the twisting his twist he three twines doth intwist; The twine that untwisteth, untwisteth the twist.

A stage-coach service was introduced in 1824 and in 1831 coal gas came to the town. In 1863 communications were further improved by the arrival of the railway. Glasgow ironmaster William Dixon was one of the prime movers of the scheme. But as the 19th century neared its end, the community seemed to be losing its dynamism. Handloom weaving was dying out as were a host of other trades and crafts which at one time had made the town almost totally self-sufficient.

However, the town was gaining a new prominence as a health resort and the opening of the new Central Station in 1904 helped bring more visitors. This trend from trade towards tourism continues yet. With an eye on its "shadow of romance thrown over the town", the castle was acquired by the Town Improvement Committee in 1912 with a view to halting its decline. Walls were made safe and pointed before ownership was transferred to the parish council. Now as I write eighty odd years on, the tower is surrounded by scaffolding and the Lanarkshire Development Agency together with East Kilbride District Council and Scottish Enterprise are funding structural repairs...

Other improvements of the late Victorian/early Edwardian period serving to make the place that bit more genteel and thus more attractive to visitors were: gravitational water supply & sewerage (1896-1907), opening of George Allan Public Park (1902), new Central Station (1904), golf courses (1897 and 1908) and slaughterhouse (1912 - prior to that the butchers slaughtered in their shops!).

Overton Avenue Entrance to Golf Course, Strathaven.

The changes of the last 95 years are chronicled so much better by the pictures which follow than by the words I could write (although it hasn't stopped me you'll see). However, to me some of the most interesting changes are those that were made in the name of 'town improvement'. The 'old town' of Strathaven was swept away by a lethal cocktail of neglect, fire, road-widening and 1950s and 60s planning. And what do we have now? A ghastly telephone exchange and an endless stream of through traffic driving too fast through a patchwork quilt of gap sites. Of course it could all be rectified. Once the Scottish Office has convinced all the doubting Thomas local authorities that the Ayrshire motorway link should be on the Strathaven-Darvel route, Strathaven will at last get its bypass. Then might be the time to think about recreating the 'old town' of Strathaven on those gap sites. What a tourist attraction that would make!

Richard Stenlake, July 1993.

STRATHAVEN – A BIBLIOGRAPHY (with comments in italics solely my opinions!)

Sinclair, Sir John ed.	Statistical Account, Parish of Avondale by Rev. Mr. John Scott, 1793. *Far more interesting than its dull-sounding title would suggest and a good starting point for further reading.*
Proudfoot, Rev. William	New Statistical Account, Parish of Avondale or Strathaven, 1835. *The first account updated (because of the rapid pace of change in Scotland during this period). Useful pieces of information about the state of the parish set amongst alternately sycophantic or damning observations of the conduct of its inhabitants.*
Robertson, Rev. C. Arthur	Third Statistical Account. Parish of Avondale 1949. Revised 1952. *Fascinating account of the parish in the post-war years.*

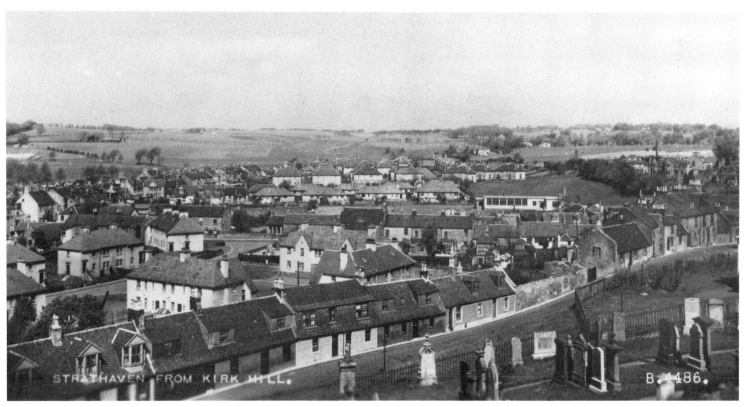

The old and the new cheek by jowl.

Mack, William	History of Strathaven 1811. Reprinted in facsimile 1911 as Centenary Reprint of History of Strathaven 1811-1911. *A small but useful book with some interesting little vignettes.*
Gebble, Mary	Sketches of the town of Strathaven and parish of Avondale, 1880. *A useful reference work with sections on notable emigres and inhabitants, the weaving and fabric trade and the area's botany amidst much other information.*
Campbell, J. Ramsay	My Ain, My Native Toun, Stra'ven, c 1945 *Unpretentious and nostalgic look at the author's birthplace. The freshness of one man's view and the vivid description of the 'memories' overcome the slightly over-sentimental style.*
Bryson, James & Bryson, Nathaniel	Handbook to Strathaven and Vicinity Guide to Strathaven and District. Several editions. *(Father Nathaniel and, later, son James produced these pocket-sized books aimed at the visitor market).*
Graham, T.F. Harkness	Scenes on the Avon (Lanarkshire) In Prose and Verse. Date? *Purple prose and poetry!*
Hamilton Advertiser	*source of many titbits of information, but regrettably has never been indexed.*
Hamilton Herald co.	Stothers' Glasgow, Lanarkshire and Renfrewshire Xmas and New Year Annual. 1911. pages 266-269.*Uncritical report of 'state of the parish' at the end of 1911.*
Brown, John	Modern Strathaven With Peeps at its Past. Circa 1948. *Another post-war publication – part history part 'memories' and part re-examination of the evidence. Contains a very full account of the town during World War II and many other useful bits and pieces. A bit chaotic and in no particular order but very very readable.*
Downie, William Fleming	A History of Strathaven and Avondale. 1919. *The most recent and probably the most definitive work covering the history of the town. Slightly marred by the omission of a much-needed index and not infallible, but then what is?*

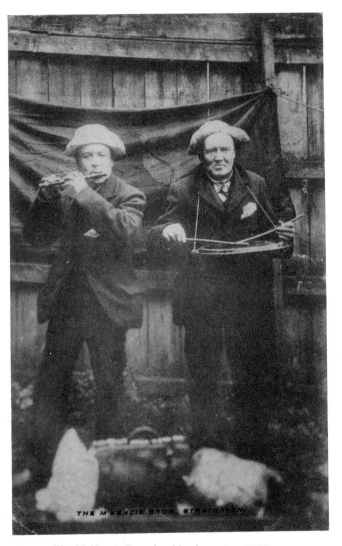

The McKenzie Bros. local buskers circa 1903.

All those overleaf are out of print. The following publications are still in print at time of this publication:

Clyde Valley Tourist Board	Strathaven, *At 5p this pamphlet must represent tremendous value. Basic background facts.*
Strathaven and District Round Table	Strathaven 100 years on. 1979. *105 'then and now' comparison pairs of photographs briefly annotated.*
Currie Bob	Strathaven in old picture postcards 1988
Currie Bob	Strathaven in old picture postcards volume 2 1989. *Two volumes of captioned old postcards and photographs.*
Howat, William D.	Avondale Guides. 1992. No.1 Sir Harry Lauder - his links with Strathaven and the World. *Chapter and verse on the life and times of the entertainer who made the town his home.*
	No.2 Stra'ven Castle. *Little 'new' information but a useful marshalling of all the known facts and fictions about this much-loved edifice into one compact volume.*
East Kilbride District Council	Time in Motion. A history of rail and bus travel in East Kilbride. Strathaven. Glasgow. 1986.*A profusely illustrated and informative 40 page booklet.*

PLEASE NOTE: *A number of the publishers of the above hide their light under bushels! If you are experiencing difficulty in obtaining these publications we can obtain them for you. Write for details.*

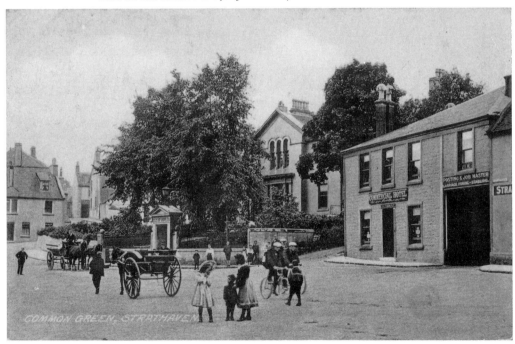

The Common Green circa 1908.

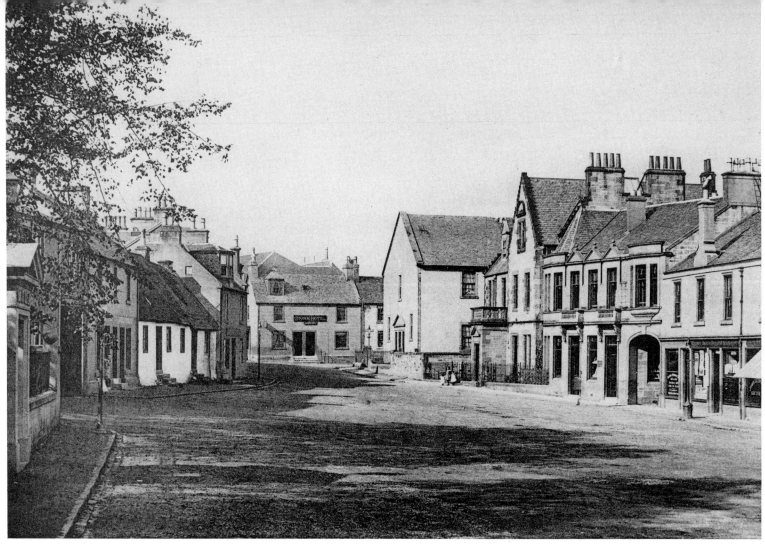

A tranquil Common Green circa 1899. On the right, at the corner of Green Street is Greenside Church, still, in use at that time. It closed in 1907 due to the minister's ill health and a dwindling congregation. On the extreme left are the gate pillars of the Bank of Scotland. The next building on the left, only partly visible, is the Commercial Hotel as was, later the Commercial Garage and now altogether gone. The garage yard provides much-needed parking space. Strathaven is now very dependent, perhaps too much so on the motor car and planning policies seem to have been 'motor'-driven. The Common Green is, like many of the town's attractive streets, over-busy with traffic and hazardous to pedestrians.

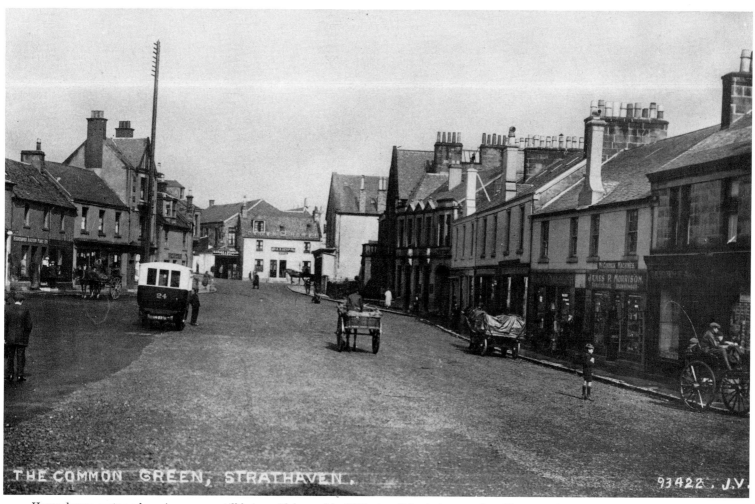

THE COMMON GREEN, STRATHAVEN. 93422. J.V.

Horse-drawn carts and carriages were still being widely used in 1924 when this photo was taken. The motor bus here belonged to Rankin Brothers, a substantial firm whose fleet consisted of over 50 vehicles – Delahayes, Beardmores, Lancias and Albions.

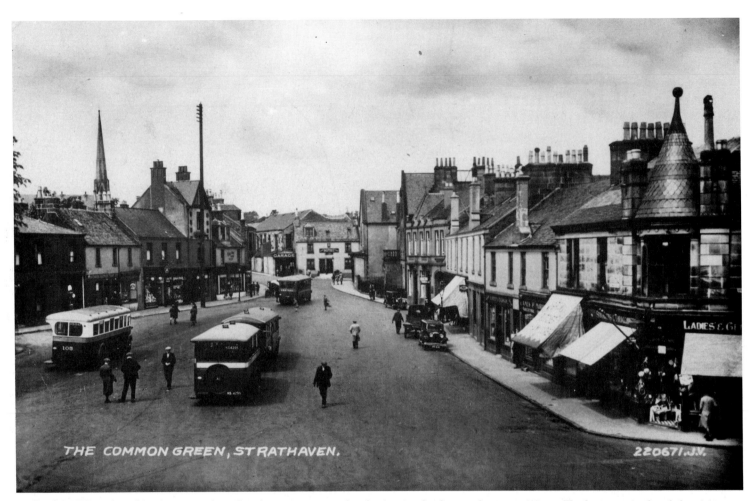

THE COMMON GREEN, STRATHAVEN.

220671.J.V.

By the 1930s, when this view was taken, Strathaven was a popular destination for day or afternoon visitors. The buses arrived and the visitors spilled out of them and into the shops and tearooms of the Common Green to spend their money. Buses still alight in the Common Green but somehow, with its crammed-in parking spaces and its mini one-way system with cut of junction and cars hurtling everywhere, it's just not the same these days!

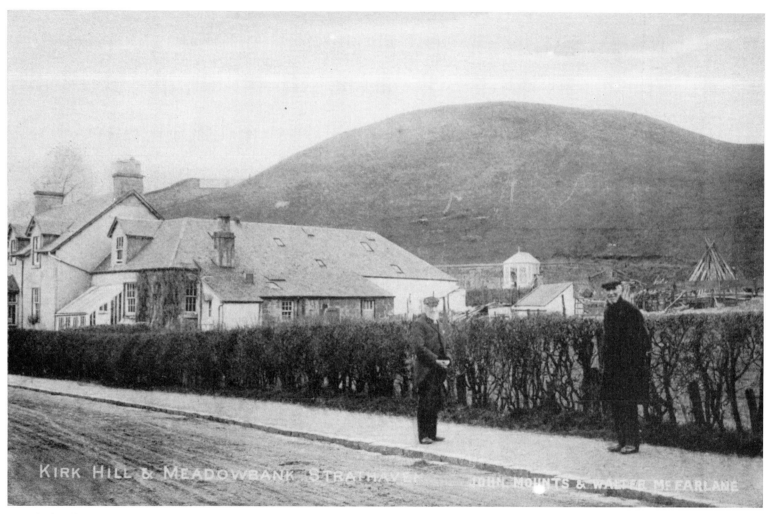

Kirk Hill circa 1905. Legend, doubtful even as legends go, has it that the hill is not entirely natural and was raised in height during 'the killing times' so that hostile forces could fire upon the castle. Later, in the calm of the 1800s, it formed part of Meadowbank Farm until it was acquired to form the 'new cemetery' around the turn of this century.

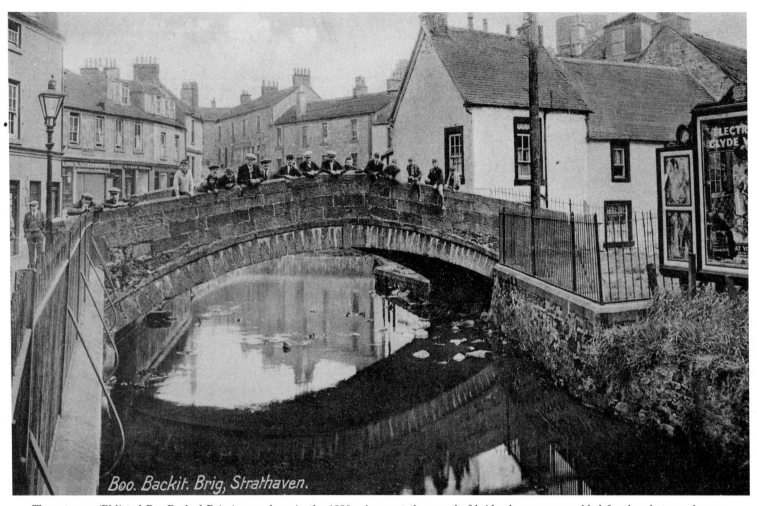

Boo. Backit. Brig, Strathaven.

The category 'B' listed Boo-Backed Brig is seen here in the 1930s. Amongst the crowd of bridge-hangers assembled for the photographer are Tommy Smith, John Crawford, George Kirk and some of the Cassidy family. On the right a poster advertises Clyde Valley Electricity. Power first reached the town in 1931, a hundred years behind gas!

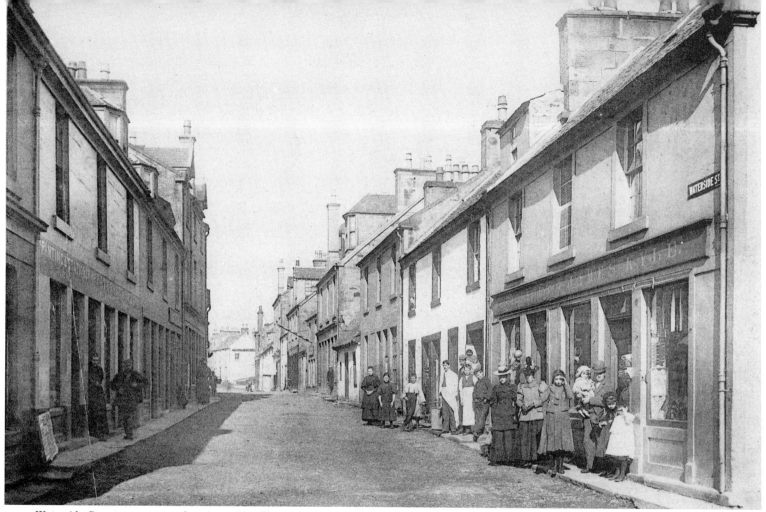

Waterside Street on a sunny day circa 1899. The street has links with two of the town's most noted businesses. In 1904 local grocer Samuel Gilmour started making the famous 'Stra'ven Toffee' in premises here (in what is now the Waterside Bar and Restaurant, I think). Most Scots would describe it as tablet. In later years it was the leading brand name, but a 1912 newspaper advert gives their Russian Toffee and Daffadown-dilly Caramels equal billing and proclaims "can't be beat for quality". There is no mistake it has been a 'sweet success'. In 1924 the firm moved its works to Commercial Road and their 'sweetie heaven' shop in the Common Green, still going strong, opened in 1927. Temptation remains in Waterside Street in the delicious aromas that waft from the premises of Strathaven's oldest firm, Alexander Taylors the Bakers. Small boutiques, galleries and craft shops add to the genteel ambience of this attractive thoroughfare, shattered every ten seconds or so by yet another motorist. Surely 30 m.p.h. is an inappropriate speed limit for such a narrow street, especially when most drivers seem to interpret it as the minimum?

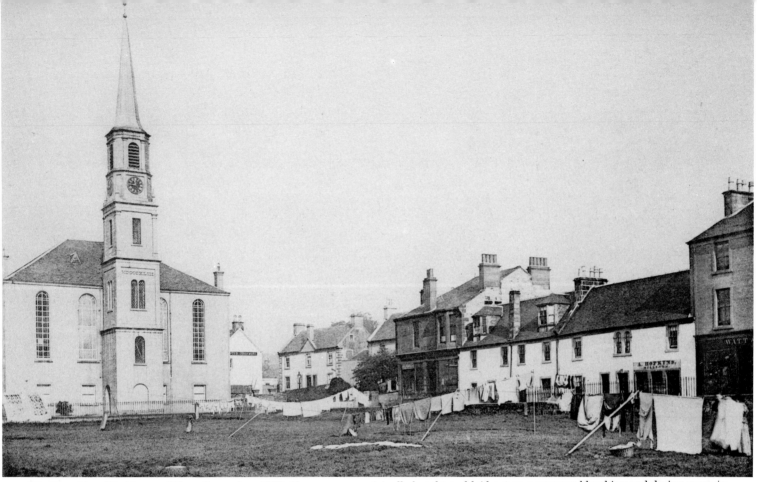

The Bleaching, Washing or Allison Green circa 1899. The green was originally bought and laid out as a common bleaching and drying green in 1775 by the four trade societies (see introduction) together with a wash-house in Bridge Street (where Alexander Taylors is now). In 1862 the green was sold, for reasons which are unclear, to a consortium of locals known as the Strathaven Bleaching Green Company. The reasons it was bought are more obvious. A business in decline was managed in such a way as to extract maximum profit. The wash-houses fell into disrepair through lack of maintenance; charges were raised (by 25% in 1883 when inflation was virtually otherwise non-existent!); and choice parcels of land were sold off periodically, the purchasers often being shareholders of the company.

In 1889 a white knight appeared. The company's shareholders probably couldn't believe their luck, Out of the blue, ex-Sandford man turned Australian sheep farmer James Allison of New South Wales wrote to the Rev. Donaldson offering to buy the Green for the town for £450. The offer was accepted and the Green, after being re-named the Allison Green, was administered by trustees before being handed over to the Parish Council in 1899. Somewhat ironically, this is the town's proper common green – the one so-named has never been common land.

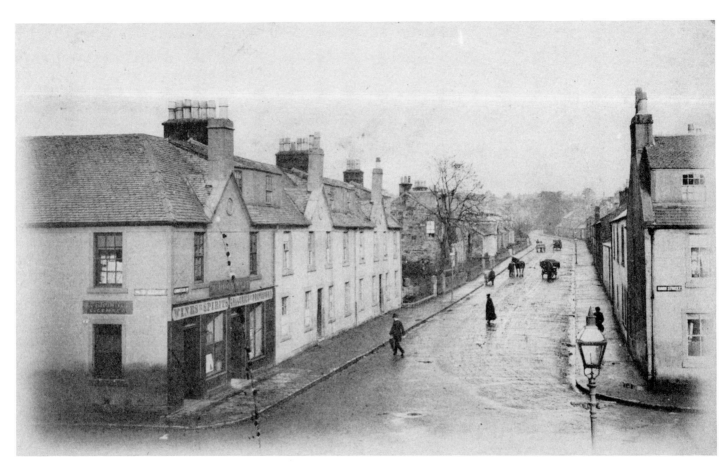

Commercial Road, here seen circa late 1902, was originally called Hamilton Road, but was renamed on account of the level of business activity there. This part of Commercial Road has seen and continues to see substantial change. On the right hand side it is pretty much the same today. Even the sign for Barn Street remains although it has been painted over the same off-cream colour as the building to which it is attached. On the left hand side, the corner building is now a small public garden, while the next buildings up are long gone. The site was subsequently used by Watson's Garage and comprised a petrol station, a workshop and thirty lock-ups. These have now in turn all been swept away by KDL Homes' present development of luxury flats. The development was to be called Dunavon Gate, but apparently the authorities insisted on the name Weir's Gate, after a previous landowner. As these sorts of development go, it is a reasonably tasteful design with its blond sandstone facing. It even has a passing similarity to the buildings seen in this photo. But what do I know? There have been plenty of takers at £75,000 a time, including the man who bought two to knock them together. At the time of writing there are only a few left! Recession? What recession?

17

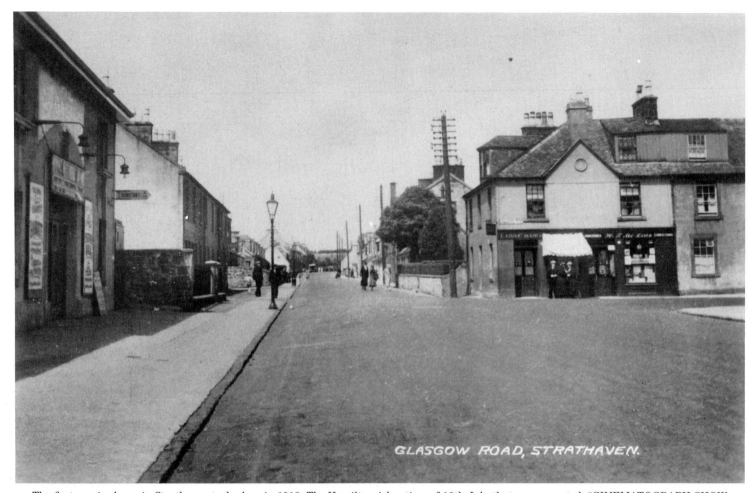

GLASGOW ROAD, STRATHAVEN.

The first movie shows in Strathaven took place in 1912. The Hamilton Advertiser of 13th July that year reported: "CINEMATOGRAPH SHOW. Mr. Swallow has erected a cinematograph show in Loudon's Park, Commercial Road, where two performances are given nightly. The pictures are on a great variety of subjects, and really good. The place is lighted and the machine operated by electricity". Later, the Crown hall in Lethame Road and after that the Public Hall in Kirk Street were used to show films. Finally, Strathaven got its own purpose-built picture-house when the Avondale Cinema in Barn Street was opened in 1930.Its life-span shadows that of other cinemas in small towns all over the country. After the boom years of the 30s and 40s attendances went into decline and as the 1960s progressed television provided the terminal blow. It closed in the early 1950s and was demolished in the 1970s. In accordance with local tradition flats now occupy the site.

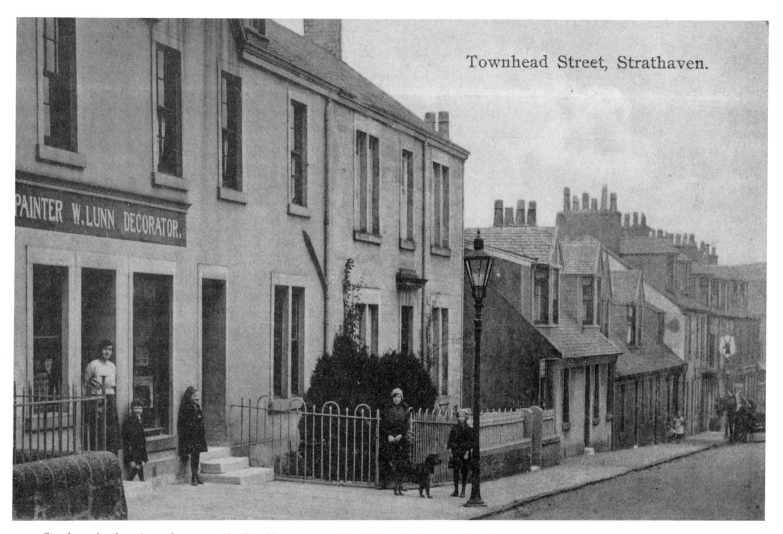

Townhead Street, Strathaven.

Strathaven's other picture house was the Ritz Cinema, opened in 1938 by Sir Harry Lauder. This view shows the buildings that went to make way for the cinema, the two properties down from where the railings end. During the war troops were billeted in the Ritz. It continued to show films as late as 1976 when it suffered the alternative fate to demolition and became a bingo hall. The building still stands and has now become – yes, you guessed it – more flats.

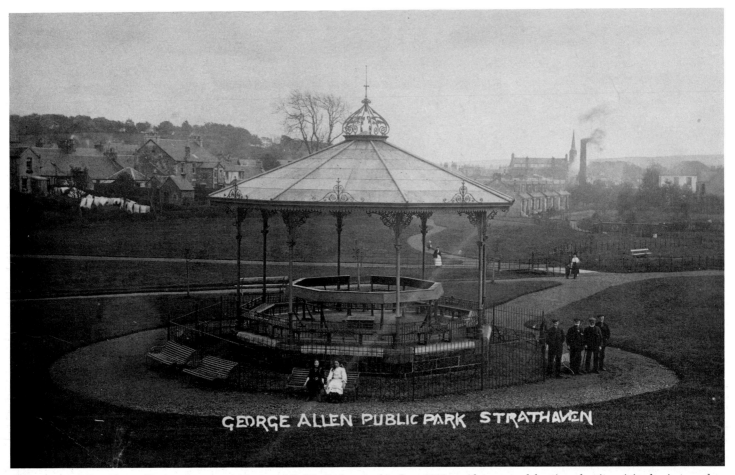

GEORGE ALLEN PUBLIC PARK STRATHAVEN

The George Allan (the spelling on the postcard is wrong) Public Park opened in June 1902, amidst great celebrations, but its origins lay in tragedy. George Allan, the only child of The Rev. James and Catherine Allan, died suddenly at the tender age of 13 in 1887 from football injuries. Catherine died five years later and with no immediate heirs, Rev. Allan left the tidy sum of £4,000 to purchase a park for the town. One of the few conditions attached was that football was not to be allowed.

In 1912 refuse was used to build up the banks of the Powmillon Burn and help prevent flooding. W's indignant letter to the Hamilton Advertiser was published on 23rd May : "Sir, is it the intention of our Parish Council to convert this beautiful park into a free coup? Surely something should be done to remove the present eyesore, in view of the prospective influx of summer visitors. If we are to court the good opinion of strangers, it is up to our council to see that the Public Park be not made a dumping ground for refuse. In their anxiety and haste to "renovate" the "ruins" of the castle they have apparently forgotten that our park requires some attention also; and yet the whole talk is of town improvement".

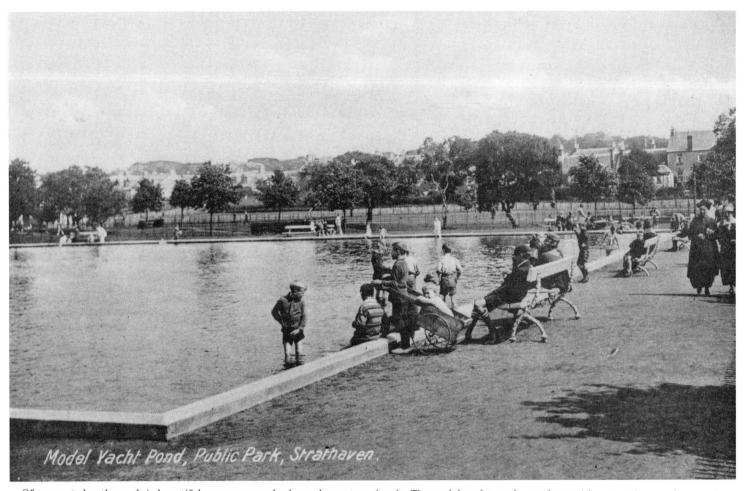

Model Yacht Pond, Public Park, Strathaven.

Of course today the park is beautiful once more and a huge draw at weekends. The model yacht pond, seen here with a conspicuous absence of model boats, was built in 1925.

The Public Park was enlarged in 1915 with the addition of the John Hastie Park, another bequest. The museum of that name opened the same year.

Strathaven Salvation Army Band 1935.

THREESTANES ROAD, STRATHAVEN

The Kirklandpark housing scheme dates from the early 1920s when it was built for the County Council. At the time this was a very select and desirable area. Few of the locals could afford the rents and as one of them put it, "Glasgow toffee noses moved in"!

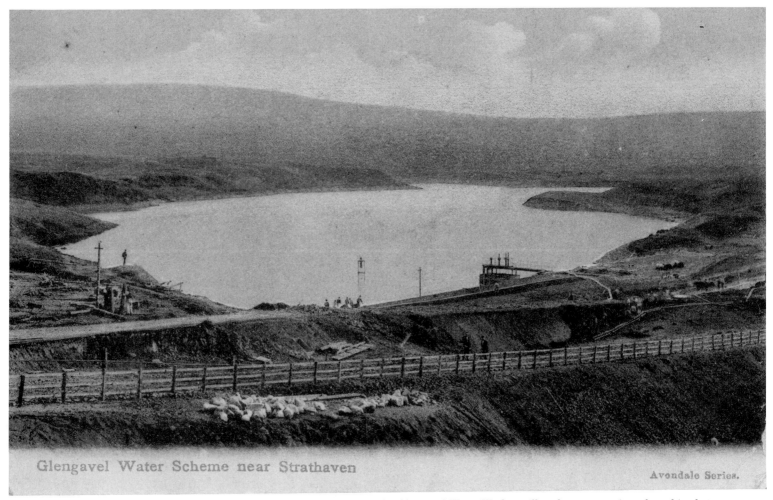

Glengavel Water Scheme near Strathaven

Avondale Series.

Up in the hills just off the wild and windswept road to Muirkirk are the Glengavel Water Works, still under construction when this photo was taken. The scheme was started in 1893 and by 1986 the first water reached the town. The reservoir level was subsequently raised a number of times and the work in progress in the photo is probably that of 1906-7. Unfortunately close inspection of the reservoir today is not practical as Strathclyde Water do all they can to discourage visitors. However, their sign is so extreme it is liable to become a tourist attraction in itself! It reads: "WARNING NO WALKING SHOOTING ETC. NO ENQUIRIES ANYONE ENTERING WILL BE CONSIDERED A TRESPASSER C.C.T.V. IN OPERATION. KEEP OUT." What have they got in there? Even the Ministry of Defence is more polite!

24

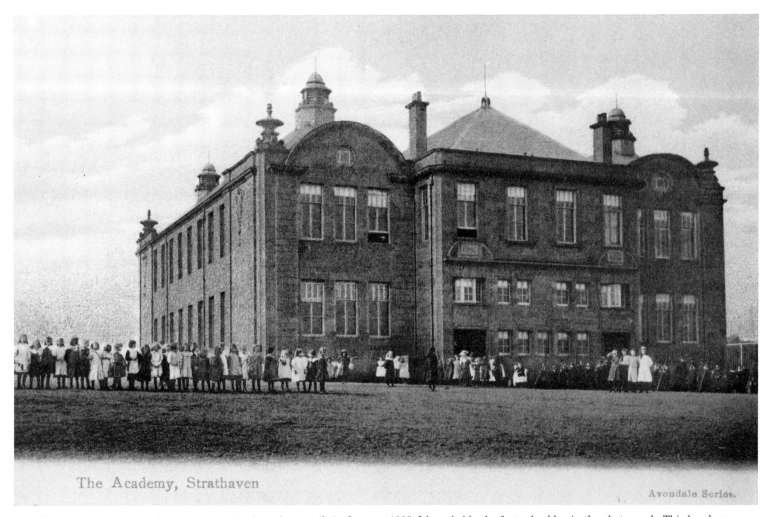

The Academy, Strathaven

The Academy was built during 1904 and took its first pupils in January 1905. It's probably the first schoolday in the photograph. This handsome red sandstone building designed by Alexander Cullen still stands, although it has since lost its cupolas (the useless looking extra bits on the roof).

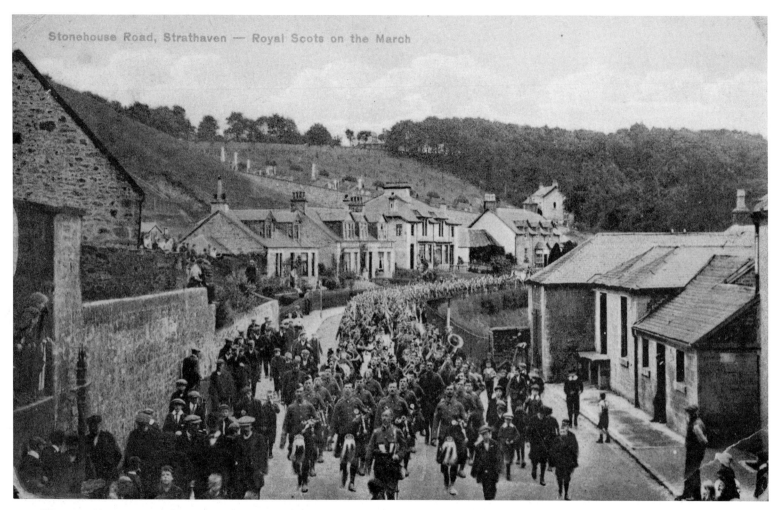

Stonehouse Road, Strathaven — Royal Scots on the March

The annual summer camp for territorials was a big event in Edwardian times. Full reports about the progress and weather at camp would fill the local papers. In July 1912 the venue was Doonfoot Camp. The local part-timers from Strathaven and Larkhall formed "L" company of the 6th Scottish Rifles (Territorial) Battalion. Here they are seen presumably en route to the Central Station together with a party of Royal Scots, who were perhaps in the area on a route march.

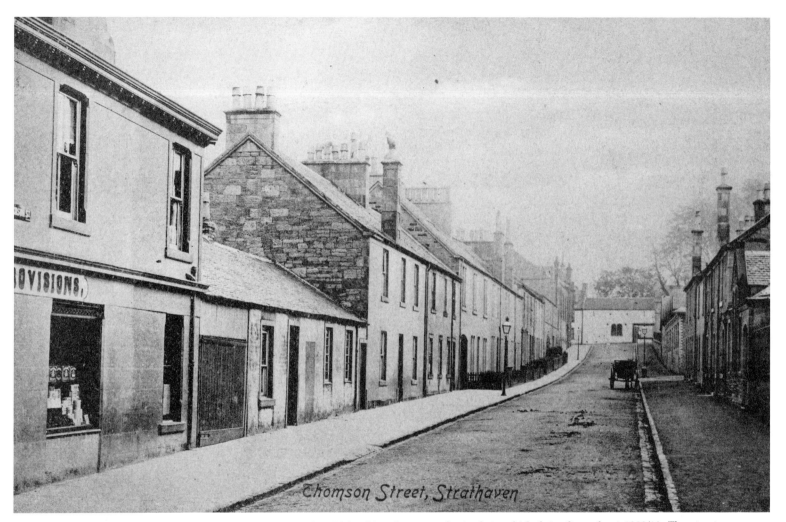

Thomson Street, Strathaven

Thomson Street doesn't look that much different now, but I like this calm atmospheric photo which dates from about 1909/10. The street was named after a cheese merchant, Andrew Thomson who owned some of the land used to lay out the street. It started life as a cul-de-sac but was made a through road in 1895 when it was extended as far as the then new Town Hall.

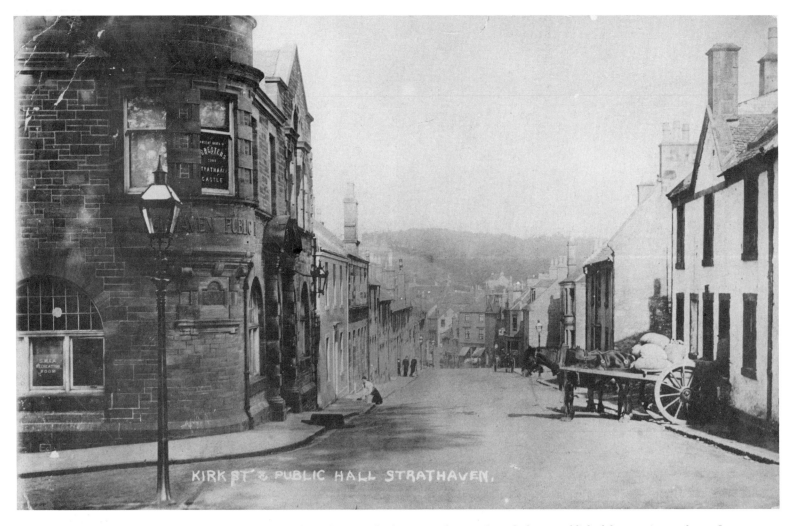

KIRK ST & PUBLIC HALL STRATHAVEN,

Kirk Street circa 1908. The buildings on the right, where the cart is loading, were the premises of a long-established firm, grain merchants James Hamilton & Sons. Besides the obvious, "Cheesey" Hamilton also sold butter and hams. The building was taken down and totally re-built about 10 years ago and is now called Arran Court (Kirk Street was previously Arran Street). Don't be misled by the stone bearing the date 1793 – it was simply re-incorporated in the new facade.

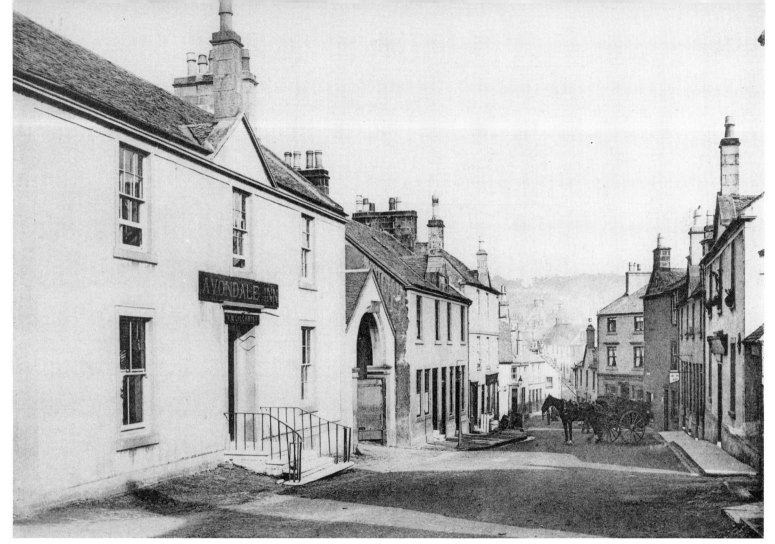

This part of Kirk Street seen here circa 1899 looked in a better state then than now. Peeling paint, broken signs and boarded windows conspire to produce an air of rundown dilapidation. This is a great shame as here are some of the older and more interesting buildings in the town. The Avondale Inn dates from the early 19th century and was built by the local Lodge "St. John". The building is currently an antique shop and dwelling-house. Next to it in the photo, where the stabling is, there has been a small infill development, now occupied by Clyde Video.

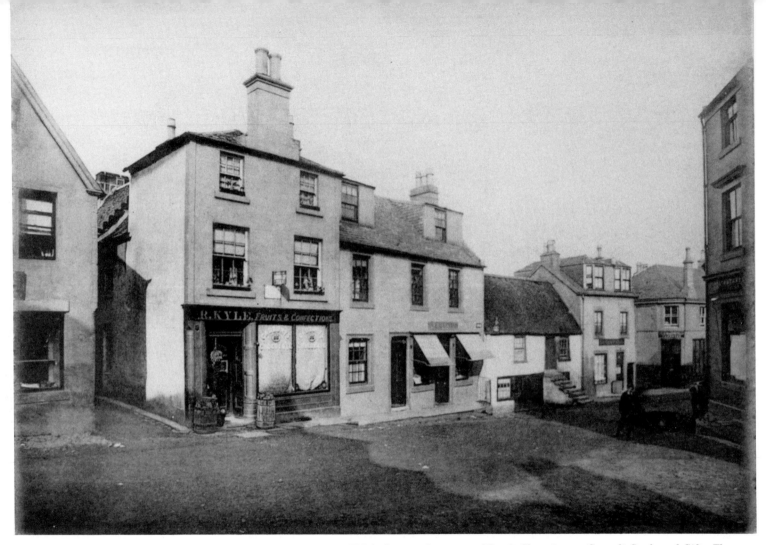

Further down Kirk Street at The Cross, again probably in 1899. Kyle's shop, at the corner of Strait Close, is now Cagault Cards and Gifts. The building down from it has gone as has the quaint thatched cottage which stood where the present pathway to the Boo-Backit Bridge is. Other casualties here are the top storey of the building down from the cottage and the one at the corner of Todshill Street. In 'My Ain, My Native Toun, Stra'ven', J. Ramsay Campbell wrote "I always think of Stra'ven in my mind's eye as viewed from the Old Cross". What would we have written if he had known what was to become of his icon?

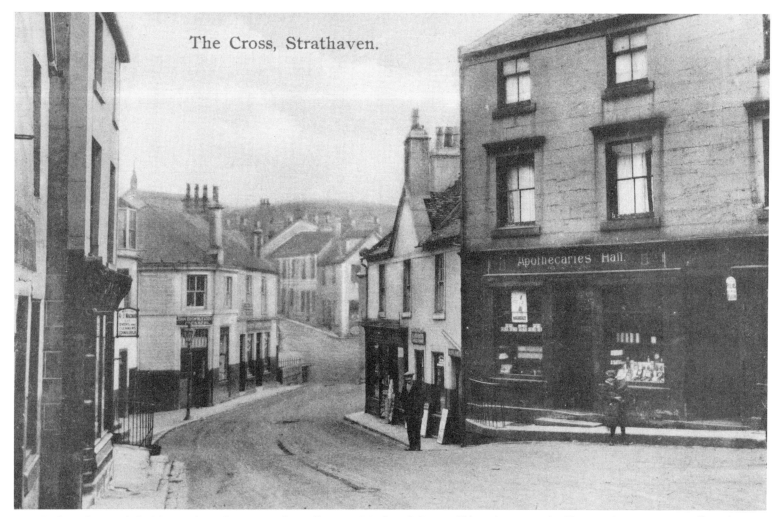

The Cross, Strathaven.

It almost beggars belief that in the early 1960s such mindless municipal vandalism could have been wrought. However, in response to traffic problems, there was wholesale demolition in the old town as many of the older buildings were removed in anticipation of a new road. After the carnage was over, there was a change of plan and it was decided to press for a bypass instead. Thirty years on an almost constant stream of mainly through traffic continues to belt past the gap sites.

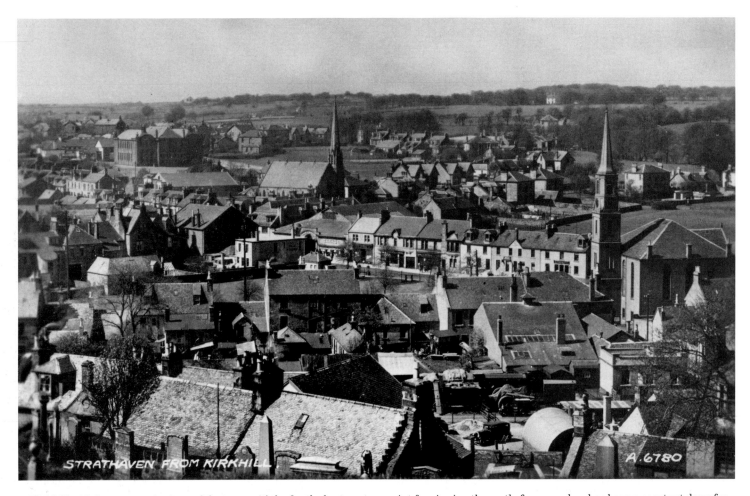

STRATHAVEN FROM KIRKHILL

A.6780

Kirkhill with its panoramic views of the town – it's by far the best vantage point for viewing the castle for example – has been a constant draw for photographers. This view dates from 1938. In Green Street can be seen the garage that stood next to the Crown Hotel as was (now the Weavers) where Gateway is now.

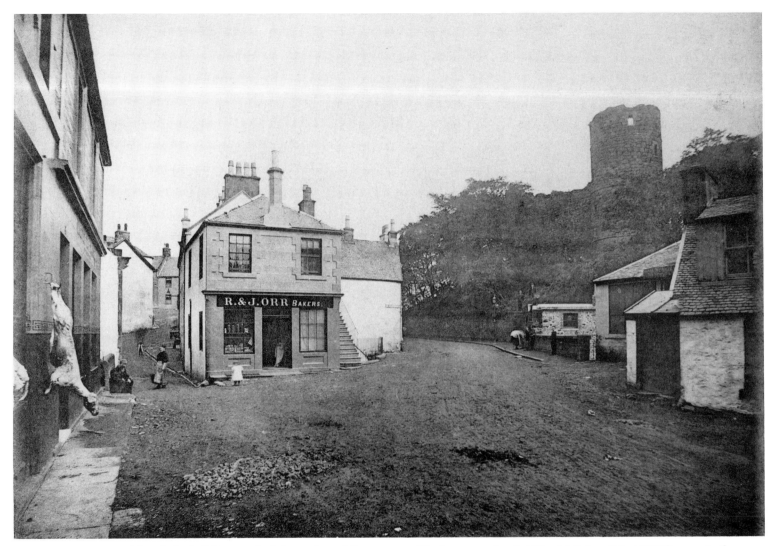

More devastation although the buildings on the left remain and the memory of the ice cream shop (middle right) demolished 1960 lives on in the artwork of the Stra'ven Toffee box. Orr's bakery closed in 1938.

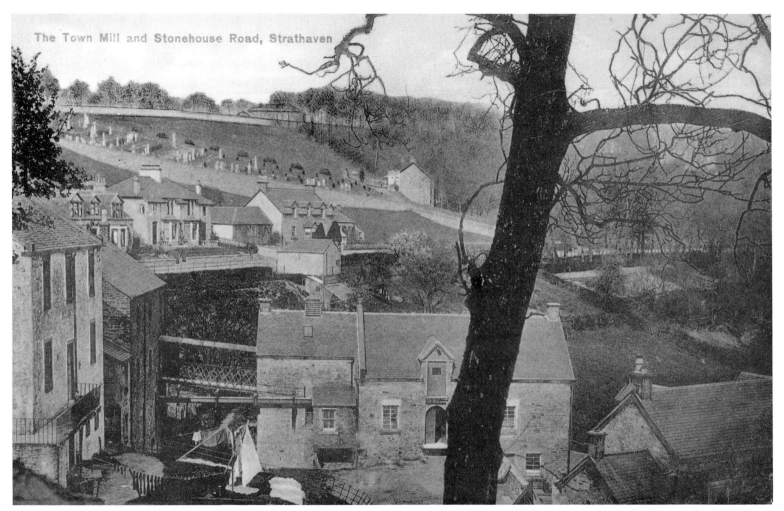

The Town Mill and Stonehouse Road, Strathaven

The Town Mill dates from 1650 and was built for the Second Duke of Hamilton on what was probably the site of the castle's bake-house. It went on fire in 1831 and was subsequently rebuilt. In 1875, still in the ownership of the Duchy of Hamilton, it was extensively reconstructed and modernised at a cost of £3,000. However, the investment was ill-timed as by the end of the century stoneground flour was no longer to the public's taste. The Duke cut his losses and sold the mill for £1400 – an early case of negative equity. The change of ownership brought a change of fortune, but in 1919 the mill was sold once more.

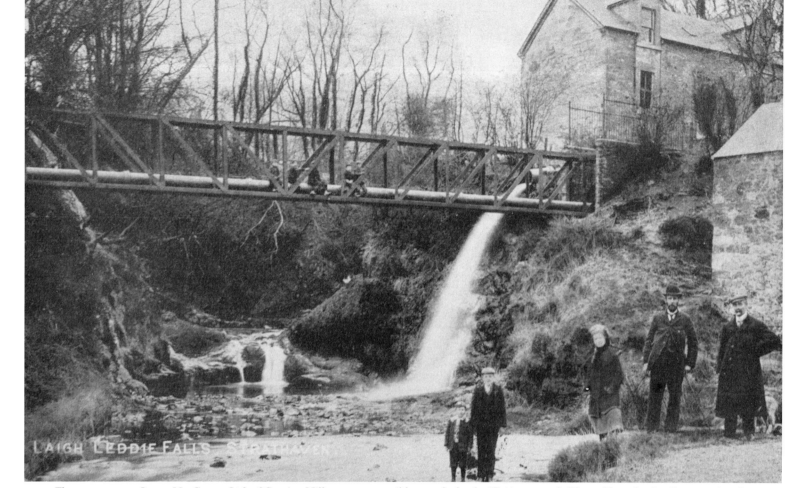

LAIGH LEDDIE FALLS STRATHAVEN

The new owners, James MacGregor Ltd. of Garrion Mills were responsible no only for the "Better canna be" legend but also for disconnecting the old overshot water-wheel and installing hydro-electricity. For a time the mill prospered, but by the 1960s the firm's fortunes were in decline and it ceased operation in 1966.

Amazingly it was neither demolished nor turned into flats. Instead, it was rescued by Strathaven Arts Guild and has been reborn as an Arts Centre. Here also, during the season, can be found the tourist information centre.

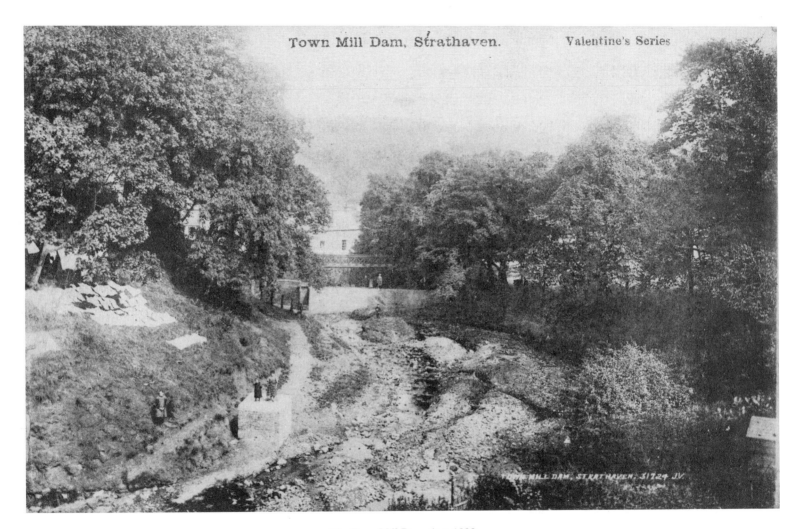

The Town Mill Dam circa 1899.

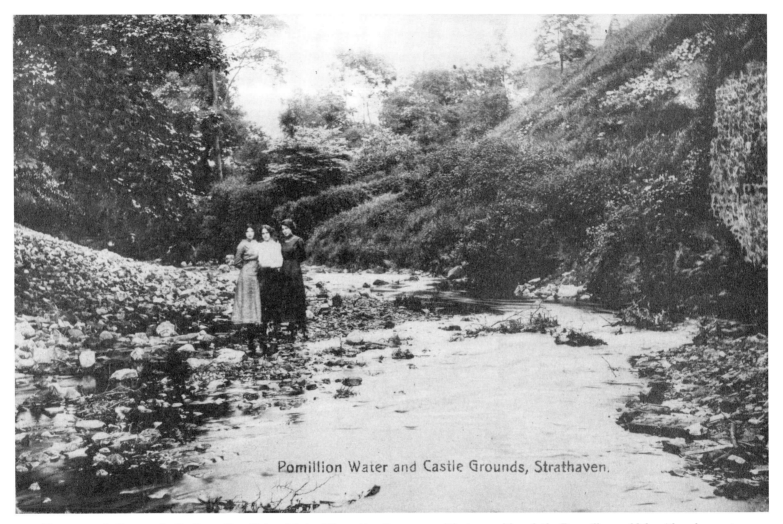

Pomillion Water and Castle Grounds, Strathaven.

Three young ladies pose by the Powmillon. Today, this is still an attractive corner of the town, although the Powmillon could do with a clean-out. As it winds its way down the Milnholm, it offers up a cross-section of a hundred years of rubbish. There are the inevitable scraps of plastic, corrugated iron and rusting drink cans, but also old bricks bearing the names of defunct local works. It's almost interesting!

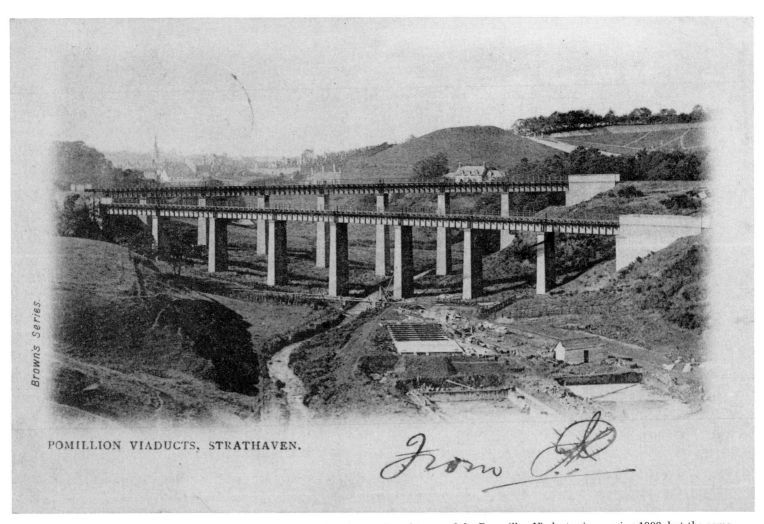

POMILLION VIADUCTS, STRATHAVEN.

You could hardly find a scene more changed in the whole of Strathaven than this one of the Powmillon Viaducts circa spring 1903, but the same could have been said then also. The viaducts were newly built in preparation for the opening of the Central Station the following year, the two years of construction of the new sewage works were nearing completion and in the background, next to a bare Kirk Hill, was the then recently laid out new cemetery.

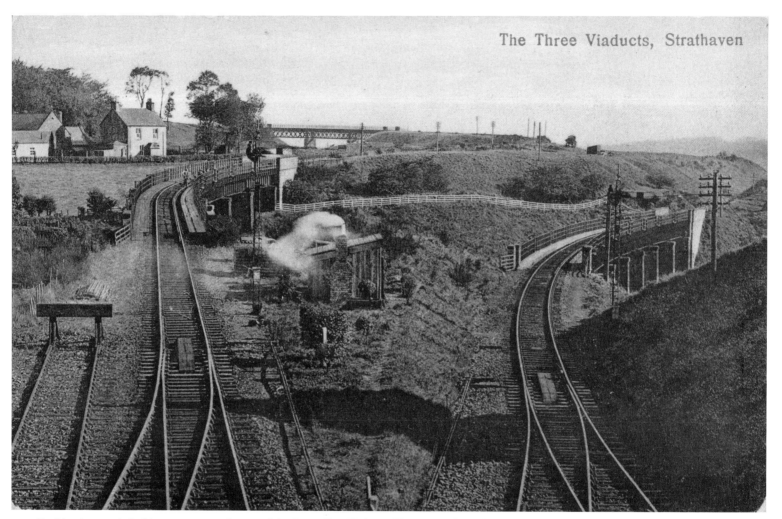

In this view one is looking east across the top of the Powmillon Viaducts. The one on the right bore the line to Stonehouse and Larkhall. The left viaduct and the one in the distance were constructed to link up the new Central Station and through traffic from Ayrshire with the old line to Glassford and Quarter.

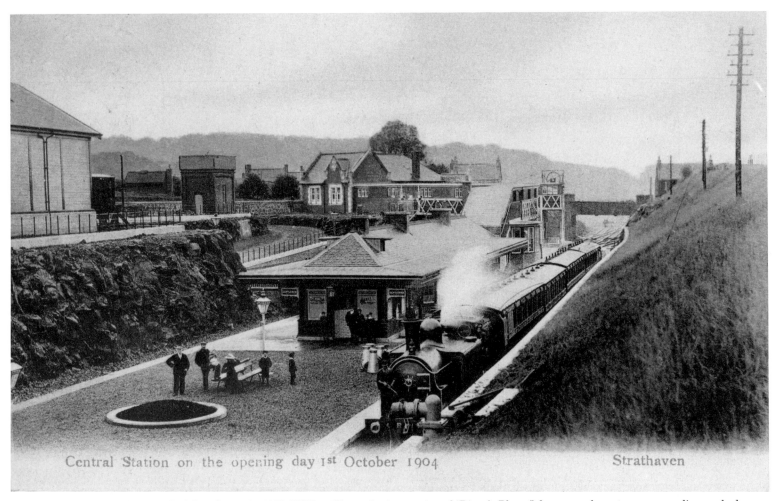

Central Station on the opening day 1st October 1904 Strathaven

The railway had first reached Strathaven in 1862. William Dixon, the ironmaster of "Dixon's Blazes" fame, was keen to see a new line pushed through another part of the Lanarkshire coalfield to keep his furnaces fed. The Hamilton and Strathaven Railway raised the capital locally and the line opened for goods in late 1862 and for passenger traffic in February 1863. Strathaven's new station (not the one seen here) was at Flemington.

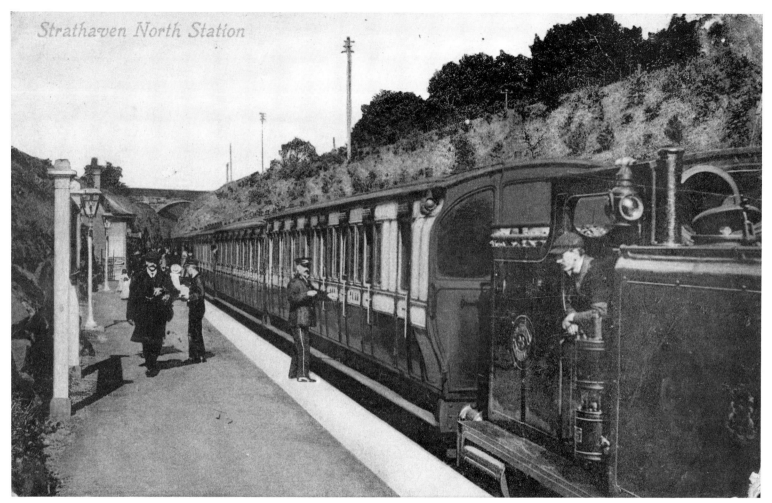

Strathaven North Station

The old station was shut the day before the new one (seen on the opposite page) opened in 1904. On the same day the newly built Strathaven North Station was opened. In the late 1890s the Caledonian Railway, who had gobbled up the minnow Hamilton and Strathaven Railway in 1864, decided to build a new route to Strathaven via Larkhall and Stonehouse. This was a time of great madness for the railway companies. Flush with the proceeds of earlier successes, they went wild, building lines that duplicated existing ones or for which there was little call. This new route to Strathaven was breathtakingly extravagant and amongst other major construction involved the building of 5 viaducts. The capital outlay was enormous.

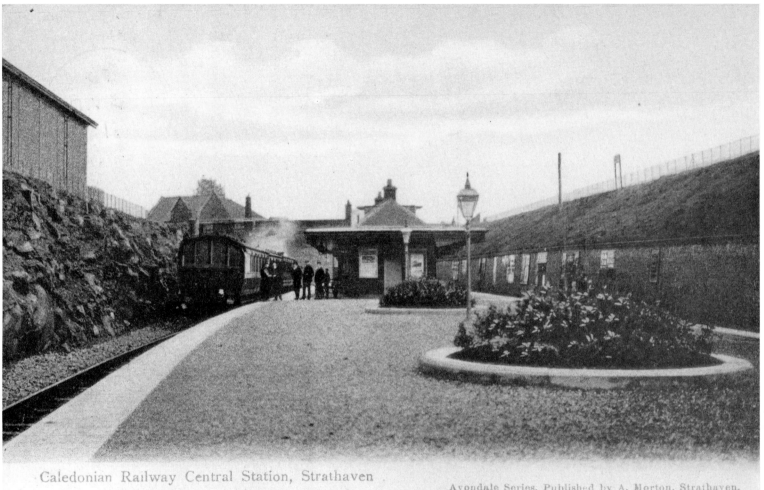

Caledonian Railway Central Station, Strathaven

Avondale Series, Published by A. Morton, Strathaven.

As output declined from the coalfields (hurting goods traffic) and competition from buses stole passengers away, the justification for the lines to Strathaven, never strong in the first place, weakened. Strathaven North and the line to Quarter closed to passengers in 1945 and to goods in 1953. Strathaven Central gasped its last in October 1965, its last trains packed to the gunnels with sentimental folk who had failed to use it previously and were now losing it. Of course these days everybody blames Beeching! Today, the station site is a sad and damp repository for the usual assorted 1990s litter and part of it has become a 'civic amenity site'. In a metaphor for the station itself in the shadow of the bridge a discarded cuddly toy lies unwanted and neglected gently rotting in a puddle.

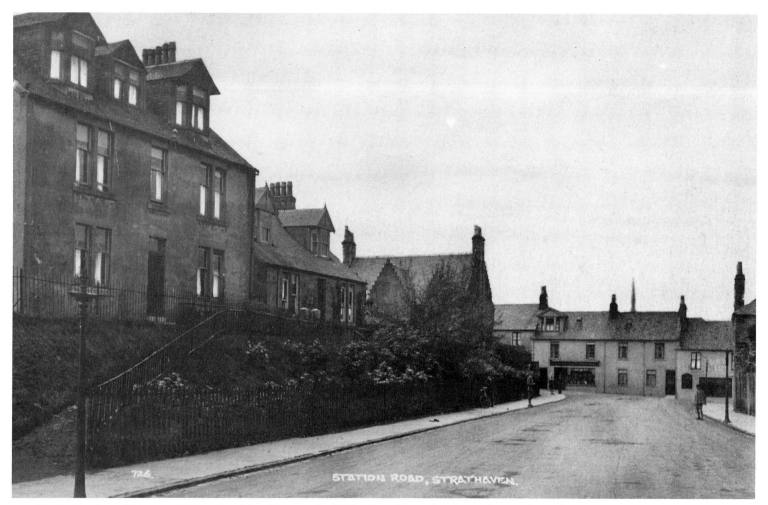

Station Road was laid out in 1904 and is pictured here in the 1920s. It used to lead to the station's goods yard, now a mini-industrial estate housing a number of firms most of which seem to have a fondness for keeping fierce-sounding dogs. Local history research in the field is certainly not for pussycats or the faint-hearted!

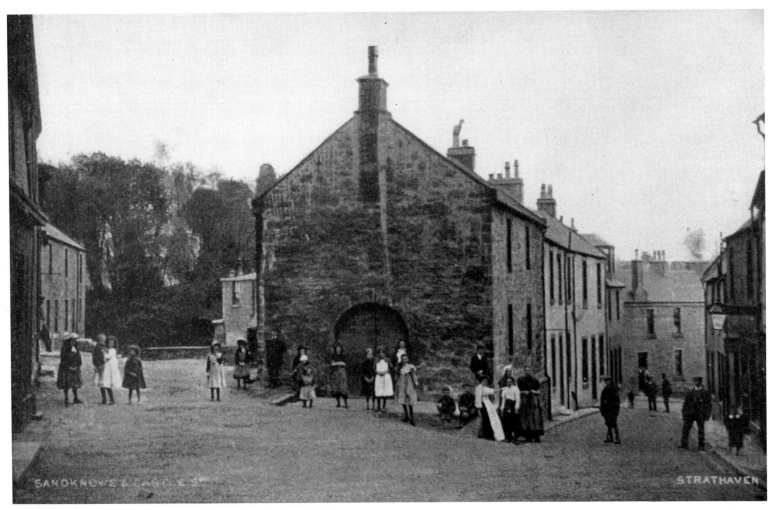

The commercial heart of the old or medieval town of Strathaven was here. In the 18th century and previously the Sandknowe was known as High-Causey and was the site of the market-place. The weekly market was held on a Thursday. Basic foodstuffs, flax, wool, shoes and other items were traded. As in all medieval towns there was a tron, used to measure quantities, of meal for example. The building seen in the foreground here was the jail, deemed of sufficient historical interest to have been spared from the wholesale destruction that took place around it in the early 1960s. It was all the more unfortunate then for it to have been stricken by fire in 1963 and afterwards regrettable that it was an easier option to demolish it than refurbish it.

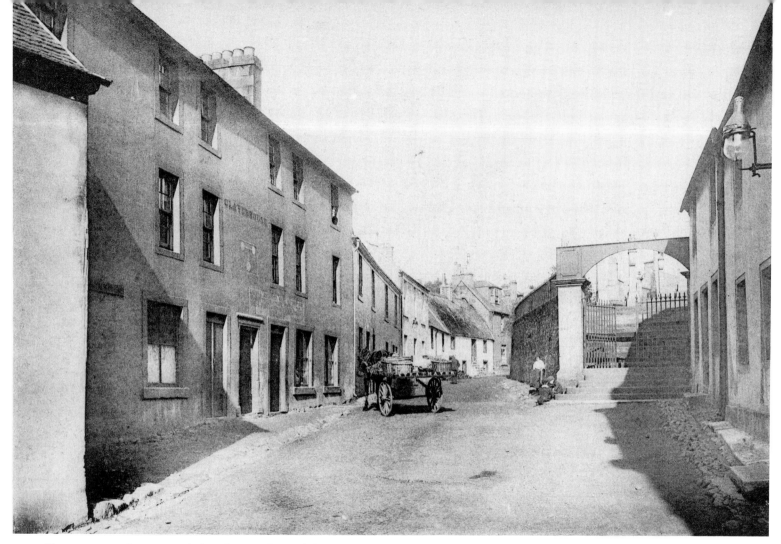

The entrance to the graveyard gives the exact locus of this view, necessary because every building seen here has gone. On the site of the building on the right stands an ugly as sin late 1960s telephone exchange. 'Claverhouse', the building on the left. was formerly an inn and took its name on account of the fact that Graham of Claverhouse and his officers wined and dined there en route to their famous defeat at the hands of the Covenanters at the Battle of Drumclog in 1679. Sometime later, it was converted to houses. Despite it being of historic interest and structurally sound, the building was pulled down in the 1930s.

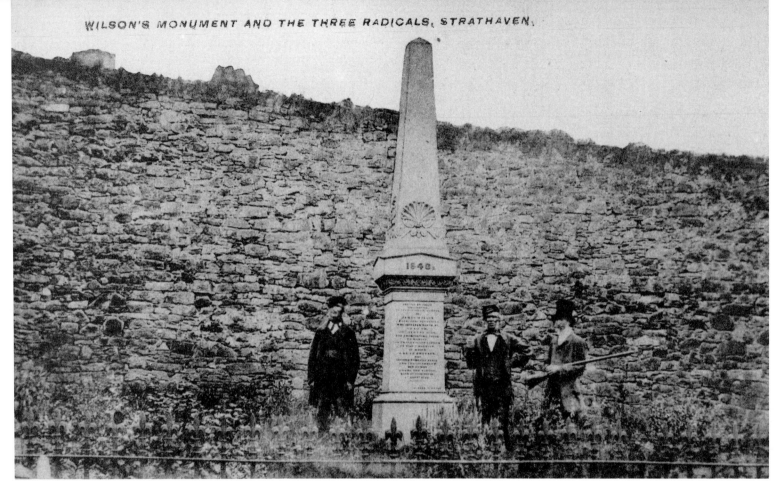

After the Napoleonic Wars the nation's economy went into recession. The Corn Laws drove up the price of food and weavers' standard of living was simultaneously being eroded by lack of work or lower rates of pay. Discontent and unrest was everywhere and like many other handloom-weavers of the time, James or 'Perly' Wilson was a Radical. At the age of 60 he was probably more given to talking than fighting, but in April 1820 the local Radicals decided to prepare weapons and ammunition for the inevitable 'rising', notice of which duly came. Today it is thought that this call to arms came from a government agent. Despite wide local misgivings, the Radicals marched to Cathkin where they were supposedly to meet a greater force with whom they would then take Glasgow. In fact there was nobody there. Wilson never even got that far, having had sufficient doubts to turn back at East Kilbride. Nonetheless, the old man was subsequently arrested, charged with High Treason, found guilty and sentenced to death. Despite public outcry and private approaches for clemency, Wilson was hung at Glasgow Green on 30th August. His coffin had only been in the ground a matter of hours when it was brought back to Strathaven and buried with more dignity in the graveyard. In 1846 this monument, paid for by public subscription, was raised on the site where Wilson's house had stood.

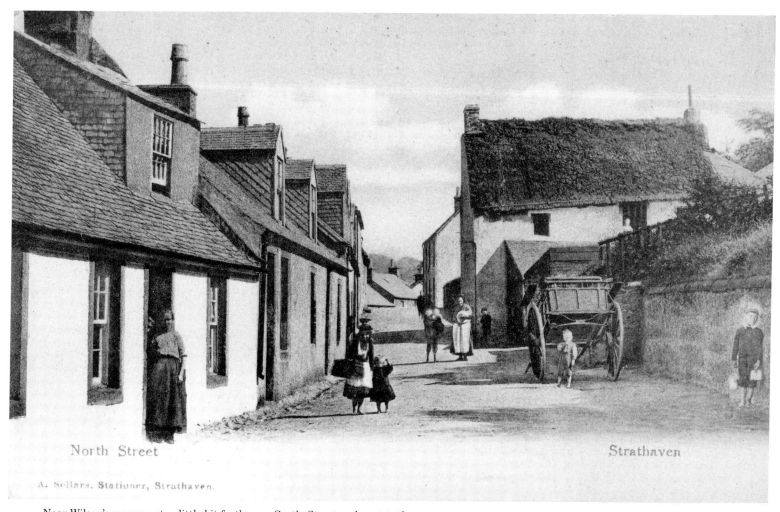

North Street Strathaven

Near Wilson's monument, a little bit further up Castle Street and next to the cemetery entrance are some particularly fine art nouveau style railings, an easily-missed feature well worth a look. Of this view, the houses visible on the left still stand. North Street's old name was Piper Row supposedly after the castle's piper who lived there. The building on the right, was known as The Thatch House and at the turn of the century it was the oldest house in Strathaven. It had previously been the Chamberlain's house and the town's head inn. Despite its age and its quaint photogenic charms it too was demolished after having stood for several centuries.

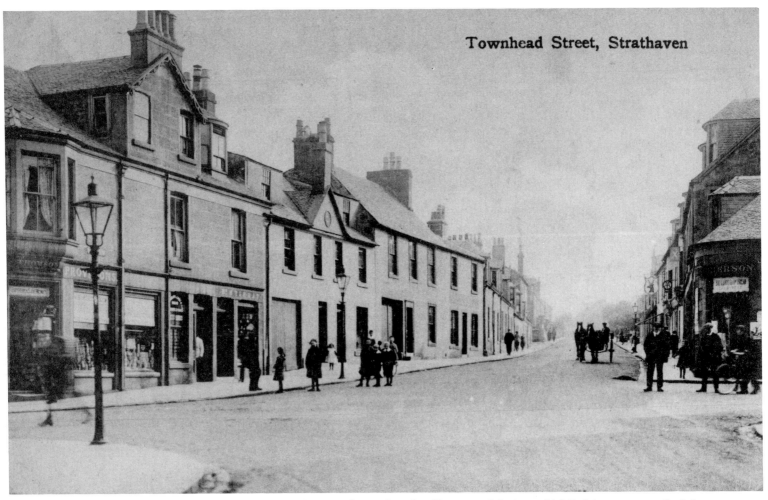

Townhead Street, Strathaven

Townhead Street, laid out in 1790, has seen much less dramatic change than the older parts of the town. Lightbody's now occupy the left corner and Stirrat's is no longer used as a shop, its frontage having been blocked up. Another building has acquired dormer windows, but the street essentially retains its appearance as seen here in Edwardian times.

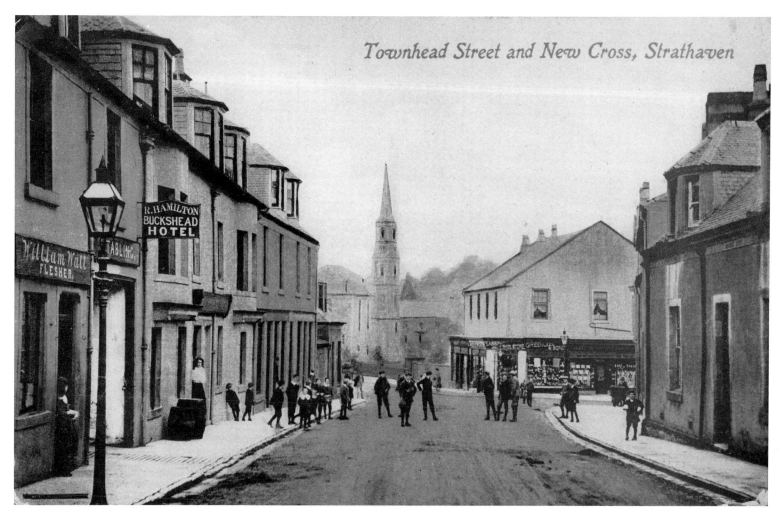

Townhead Street and New Cross, Strathaven

Townhead Street circa 1906.

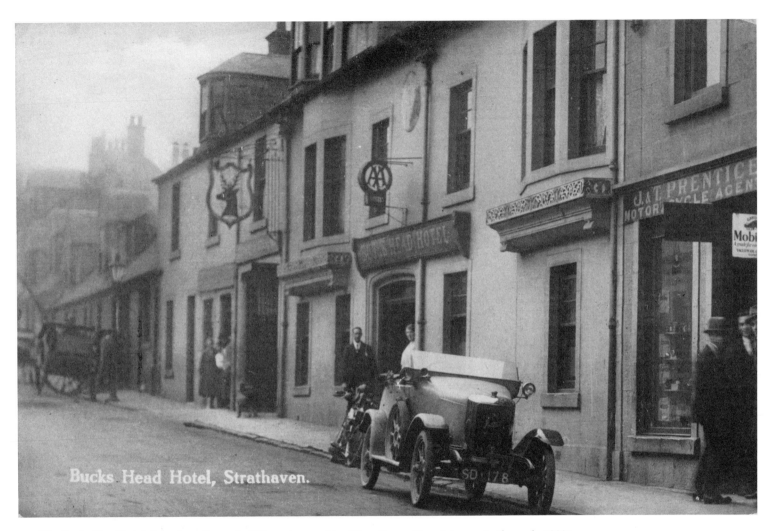

Bucks Head Hotel, Strathaven.

The Bucks Head hotel dates from the early 19th century and is still on the go. Here it is seen in the early 1920s.

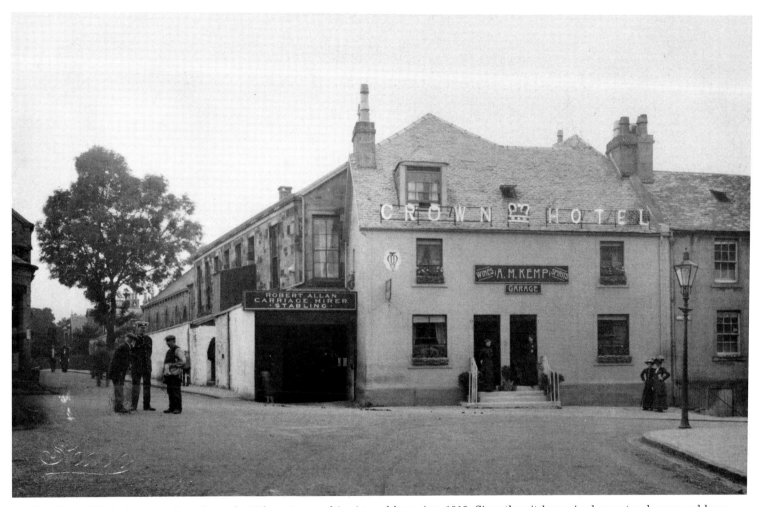

The Crown Hotel also dates from the early 19th century and is pictured here circa 1913. Since then it has gained an extra dormer and been renamed 'The Weavers'.

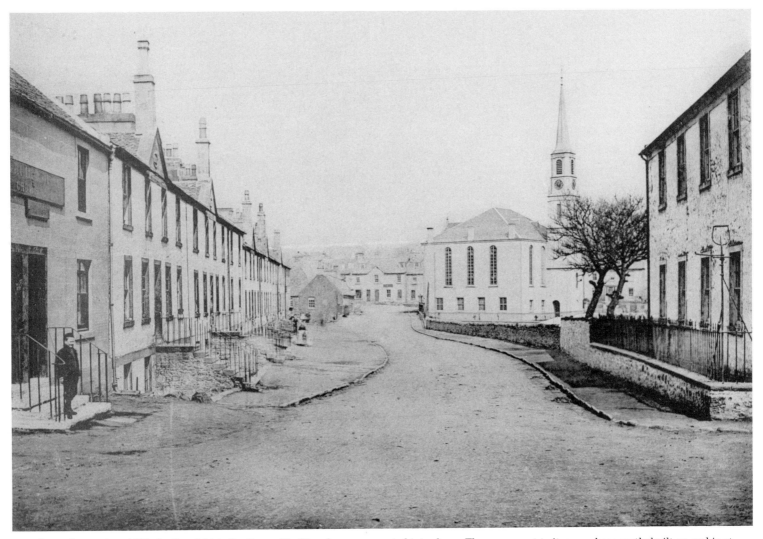

Green Street circa 1899. On the right is the Greenside Church, now converted into shops. The space next to it was subsequently built on and is at the time of writing occupied by a hot food takeaway and a vacant shop. On the left the nearest building is the Crown Hotel. The two fine buildings next to it were destroyed by a fire in the 1920s and a garage was built on the site.

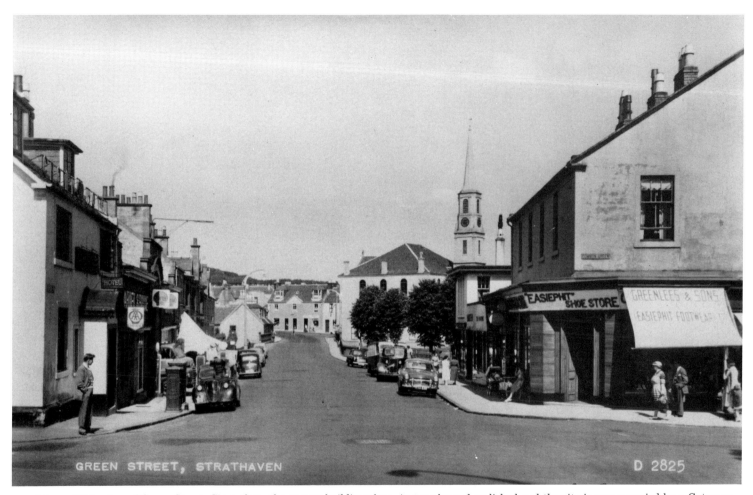

GREEN STREET, STRATHAVEN D 2825

A busy 1950s view of Green Street. Since then, the garage buildings have in turn been demolished and the site is now occupied by a Gateway supermarket housed in an ugly concrete faced building and next to it another takeaway. Is this progress or is it just change? A hundred years ago Strathaven was a major producer and 'exporter' of cheese and veal and the profits were retained in the town. And now?

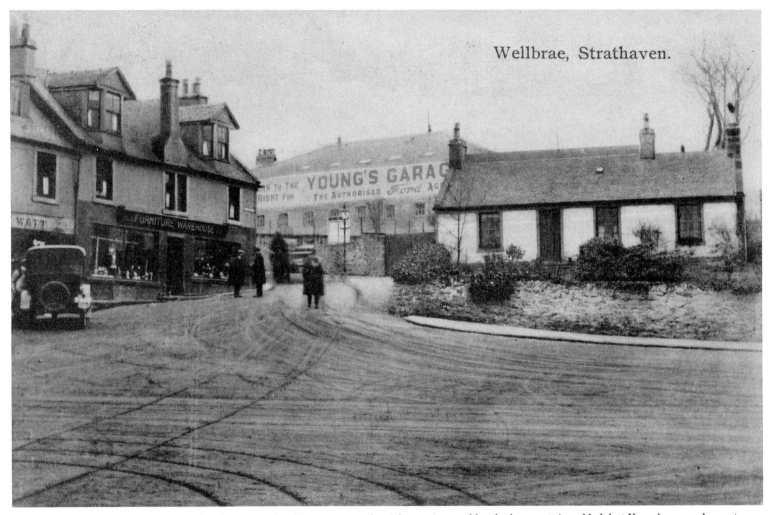

Wellbrae, Strathaven.

The bottom of the Wellbrae on a dreich overcast day. The cottage on the right survives and has had an upstairs added, but Young's garage has not fared so well. The buildings lie derelict.

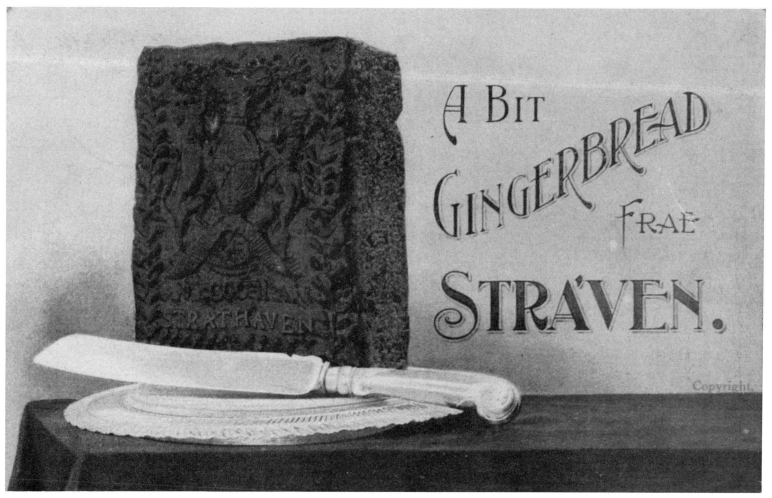

A BIT GINGERBREAD FRAE STRA'VEN.

Copyright.

Stra'ven Toffee is famous yet, but at one time Stra'ven Gingerbread was renowned at home and abroad. The story began in 1744 when a Glasgow baker, name unknown, set up shop in Strathaven. He was succeeded by Andrew Cochran whom William Mack, obviously a fan, extolled in 1811 as having "carried it to an unrivalled pitch of perfection". The family continued to make the gingerbread in their Main Street premises into this century. This postcard, posted in January 1907, bears the message "Did you ever taste Stra'ven's famous Gingerbread? Try a piece of this". The gingerbread, made from a special recipe, was exported as far away as the East and West Indies! Alas, with the demise of the Cochran family the secret recipe was lost never to be discovered since.

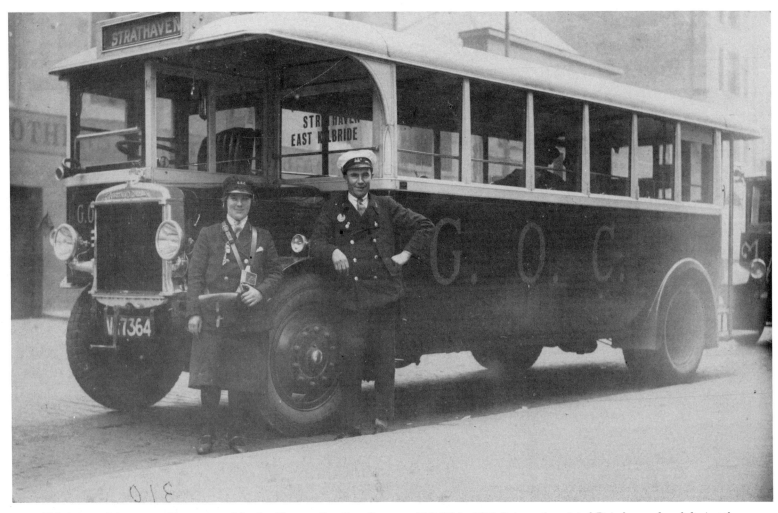

This is one of the group of buses owned by the Glasgow Omnibus Company (G.O.C.) in 1926. It is an Associated Daimler produced during the short-lived amalgamation of A.E.C. and Daimler and was probably photographed in Cathedral Street, Glasgow before setting off for Strathaven via East Kilbride.